HIGHLIGHTS

ROYAL BRITISH COLUMBIA MUSEUM AND ARCHIVES

ROYAL **BC** MUSEUM

VICTORIA, CANADA

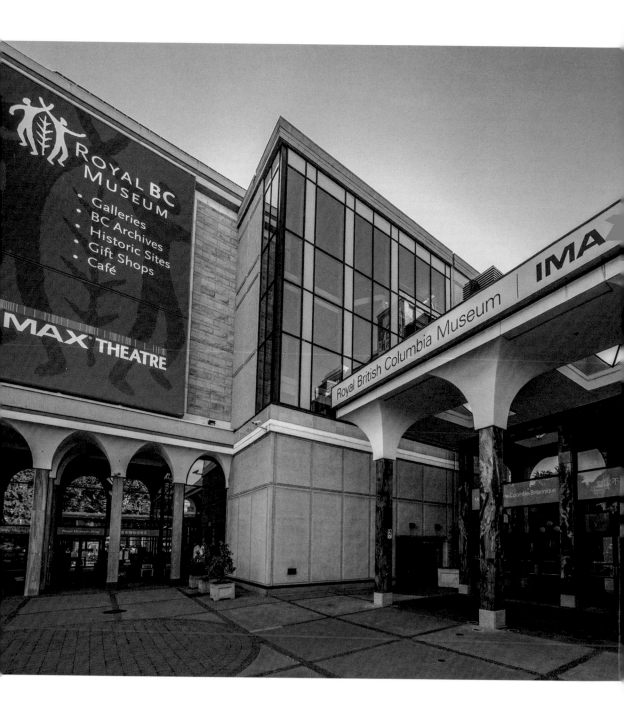

CONTENTS

Title page: Kwakwaka'wakw, Haida and Gitxsan poles stand before the western wall of the lobby.

Foreword

IN 1886, a group of leading citizens in British Columbia signed a petition that demanded a public museum be founded to stop the flow of precious First Nations objects out of the province. They were concerned that collectors and anthropologists were assisting other museums in North America build up their collections of what were then called "Indian Antiquities". This group of citizens—led by Sir Matthew Baillie Begbie, the first Chief Justice of the Supreme Court of the new province of British Columbia—took their petition to the Queen's representative, and in the same year the province's first museum was created, with John Fannin as its curator. Fannin's portrait, wonderfully captured by artist Sophie Pemberton, is in our collections.

The provincial museum had several homes before architect J.A. Cochrane won a competition to design the present building in the 1960s. Her Majesty the Queen Mother laid the foundation stone in March 1966 for a set of three buildings that cost more than nine million dollars. Over time, other architects added to the complex.

The first attempts to build a comprehensive collection were directed by Francis Kermode, and subsequent directors and curators built the collection to become one of the largest in Canada. Today, the Royal BC Museum houses more than seven-and-a-half million objects. As with all great narratives, the stories associated with these objects involve history, geography and anthropology, with large doses of personal adventure and mystery.

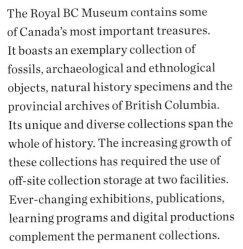

← A petition calling for a provincial museum, signed by leading citizens of British Columbia in January 1886. I-67828.

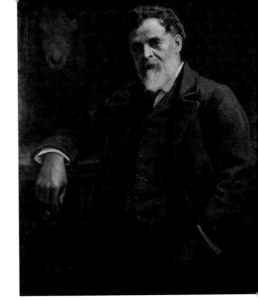

→ John Fannin by Sophie Pemberton.

The Royal BC Museum contains some of Canada's most important treasures. It boasts an exemplary collection of fossils, archaeological and ethnological objects, natural history specimens and the provincial archives of British Columbia. Its unique and diverse collections span the whole of history. The increasing growth of these collections has required the use of off-site collection storage at two facilities. Ever-changing exhibitions, publications, learning programs and digital productions complement the permanent collections.

The Royal BC Museum serves a wide spectrum of visitors, researchers, academics and students in Canada and around the world. Its research assists numerous government bodies, businesses and industries, and its learning programs touch thousands of young people each year. Canadians are proud of their history and take great pride in the care, stewardship and leadership of this great cultural treasure.

Over the coming years, we aim to expand the museum's facilities and programs to put more of our collections on show and reach out to more visitors across the world.

JACK LOHMAN
CEO, Royal BC Museum

British Columbia's Museum

THE PROVINCIAL MUSEUM OF NATURAL HISTORY AND ANTHROPOLOGY opened on October 25, 1886, in the provincial government's original legislative building, a wooden structure affectionately called "the birdcages". In 1898 the government moved into its new legislature, the grand stone edifice designed by Francis Rattenbury that still dominates Victoria's Inner Harbour. The museum took up residence in the east wing, where John Fannin, its first curator, found more space to display his personal collection of stuffed animals and an exhibition of First Nations artifacts.

■ From these small beginnings, the museum expanded its collections and displays. Francis Kermode took over from Fannin in 1904 and presided over the museum's steady growth until 1940. The next director, Clifford Carl, introduced the museum to the public through a variety of programs and publications aimed at general audiences.

In 1968, the newly named British Columbia Provincial Museum moved to its present location and increased the scope of its collections to include all aspects of human history in the province. The museum flourished throughout the next two decades and in 1987, following its 100th birthday, Prince Phillip, Duke of Edinburgh, visited the museum and gave it a new name directly from Queen Elizabeth II—the Royal British Columbia Museum.

In 2003 the museum merged with the BC Archives. The Royal British Columbia Museum now includes the massive collections in the museum and the archives, along with Thunderbird Park, Helmcken House, St. Ann's Schoolhouse and the Netherlands Carillon Tower.

At 130 years old, British Columbia's museum continues to grow. Improved digital access to our collections and

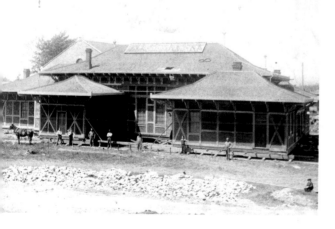

← **The first museum was housed in a small room next to the provincial secretary's office, in the original legislative building.** A-02575.

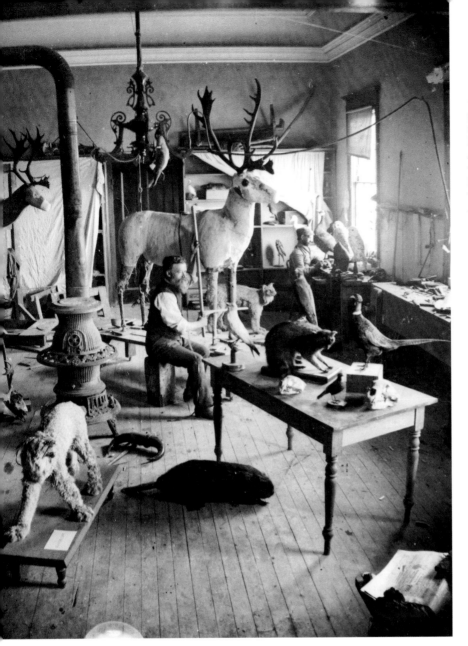

← John Fannin
prepares specimen
mounts in about 1887.
In the far corner sits
Albert Maynard,
who may have
been the museum's
first volunteer.
A-0308512.

partnerships with other Canadian museums will extend our cultural reach. New galleries and special exhibitions, planned to be installed in time for Canada's 150th anniversary celebration in 2017, will show BC's unique place in our nation.

The museum has evolved from a small collection of antiquities and stuffed animals into a dynamic, progressive institution of learning and discovery. Our plans for expansion promise more opportunities and a greater ability to share British Columbia's stories with the world—a bright future indeed.

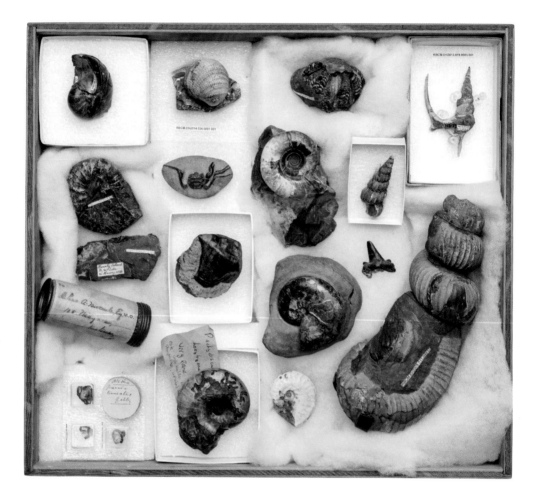

↑ Fossilzed clams, snails, crabs,
ammonites, and even the tooth
of a shark, of the Cretaceous
Period—75–80 million years
ago—from eastern Vancouver
Island and Gulf Islands.

The Collection

FROM ITS INCEPTION the museum has been collecting artifacts and specimens related to the natural history of British Columbia and the cultures of its people. Most of our collections reside in two buildings on the plaza a few steps west of the lobby entrance. The low building holds our archival collections—documents, books, photographs and film. The tall building, named after John Fannin, houses millions of natural history specimens and historical objects. Both buildings are overflowing, so some collections have to be stored off site.

■ Museums around the world collect and preserve objects for a variety of reasons, many specializing in a particular subject or a well-defined region of heritage. The Royal BC Museum specializes in the study of British Columbia, which at more than a million square kilometres (including its marine territory), is no small endeavour. Our natural history collections contain millions of specimens that help us understand the biological diversity of this province and the world. The history collection documents the many cultures of people who have contributed to the development of BC and Canada. The First Peoples collections not only include splendid artworks but contribute to the foundations of cross-cultural reconciliation and partnerships.

We provide public access to our collections and lend objects upon request to other research institutions. Our print publications and rapidly expanding digitization programs bring more information to the world. And our exhibitions continue to show visitors how this province came to be, what it's like now and what it could become.

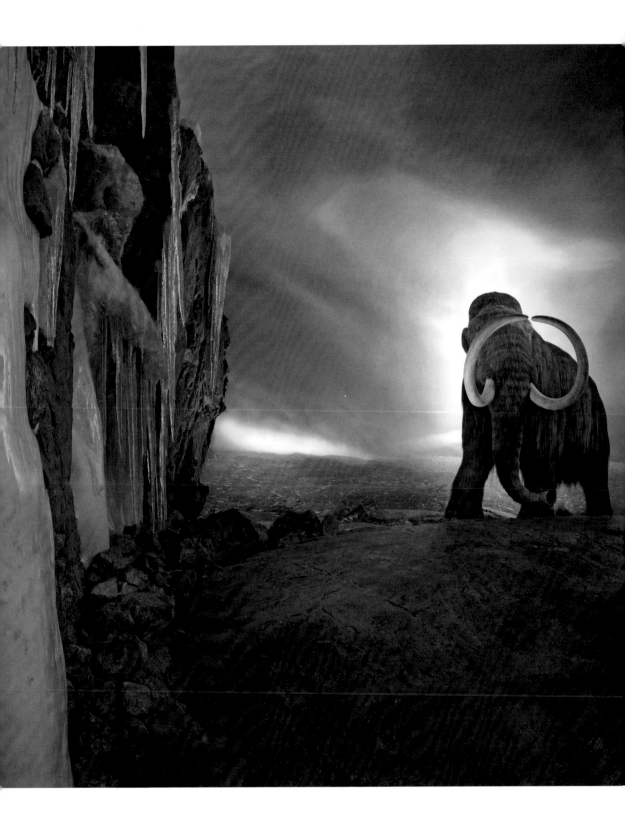

← The Woolly Mammoth was the largest mammal that ever walked on this continent. Three species of mammoths lived in this region until their extinction about 10,000 years ago.

The Exhibitions

OUR EXHIBITIONS have earned international acclaim for their drama and realism. Most of you who visit them come away with at least one memorable experience. You might have felt the awesome size and power of our Woolly Mammoth as you approach its icy world, or the richness and vitality of BC's coastal First Nations when strolling among the poles in the totem gallery. It might be something small like glimpsing a Steller's Jay in the forest display or the smell of apple pie in the Old Town kitchen or creosote as you board Captain Vancouver's ship, *Discovery.*

■ These finely detailed displays invite you to return for another look, from a different angle, even if simply to experience, in a way, another part of the province or another time. They attempt to help you understand the living landscapes and cultures of British Columbia and inspire discussions with family and friends about the future of this place or any place on Earth.

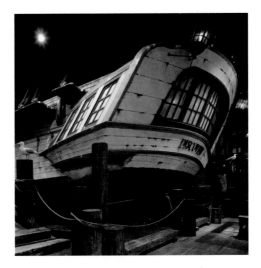

↑ This replica of the HMS *Discovery* follows the specifications of the original ship right down to the trim in British Admiralty colours.

SECOND FLOOR

Natural History Gallery

LUSH FORESTS of giant ferns and palm-like cycads thrived in the humid subtropical climate of this region during the Late Cretaceous Period, 95 to 65 million years ago. In these ancient forests lived the last of the dinosaurs.

Our Natural History gallery begins at the beginning, as the land formed to create the region we now call British Columbia. It moves swiftly through the geological epochs, then briefly visits the last ice age before arriving in the modern era. Here and now, it explores the varied landscapes of the province, with an emphasis on our coastal regions.

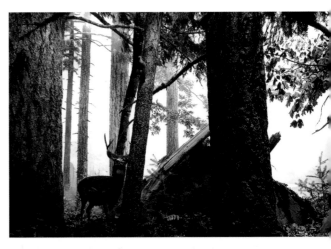

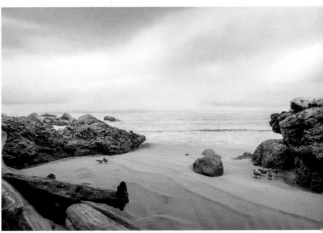

A Changing Past

FOLLOW THE TIMELINE FORWARD through the Paleocene Epoch, the Eocene, Oligocene, Miocene and Pliocene, as continents drift apart and collide, ocean levels fall and rise again, glaciers push forward and retreat.

In the most recent ice age, unmelted snow compressed under its own weight to form a great ice sheet, up to three kilometres thick, that covered much of the land we now call British Columbia for thousands of years.

About 10,000 years ago, the global climate became warmer, the glaciers shrank and melted into lakes and rivers, animals and plants spread out from ice-free regions or moved in from the south. So began the Holocene Epoch, the modern era.

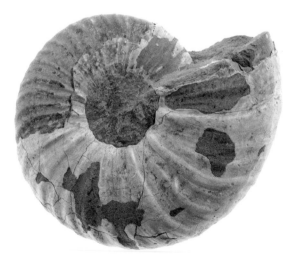

← A fossil ammonite, a type of mollusc that lived about 70–85 million years ago. Ammonites lived in the warm ocean off the shore of what is now British Columbia and ranged in size from 2–200 cm across.

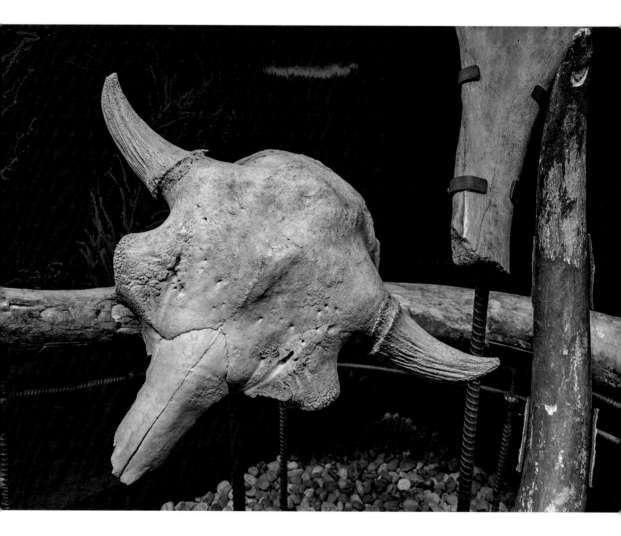

↑ The fossilized skull of *Bison antiquus*, a long extinct species of bison.

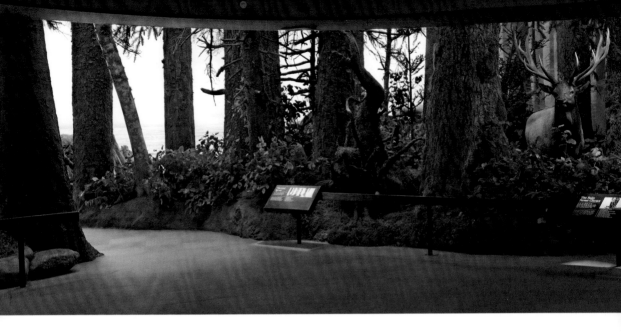

The Majestic Forest

BRITISH COLUMBIA'S widely varying climates and landscapes support a dozen different kinds of forests, but the temperate rainforest dominates the coast. Moisture-laden air from the North Pacific rises up the slopes of the coastal mountains, where it cools and falls as rain or snow, mostly in winter.

All this water falling on the coast, along with relatively mild temperatures, makes ideal conditions for growing some of the largest trees in North America. This unique ecosystem supports towering evergreens such as Douglas Fir and Sitka Spruce, their branches forming dense canopies that keep moisture in the forest. At their feet, Salal, Devil's Club and Skunk Cabbage enjoy the damp, cool environment.

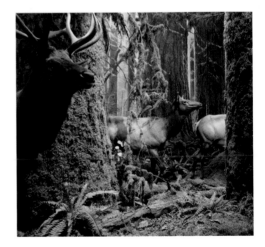

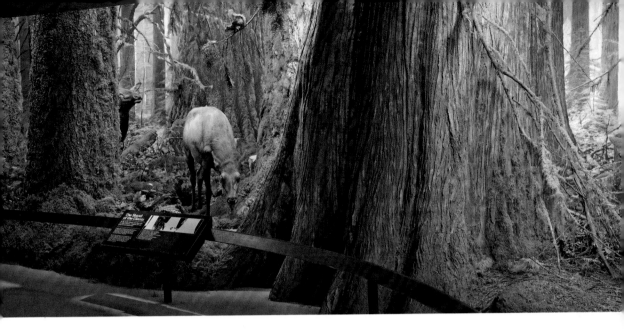

Important Microsystems

SOME ECOSYSTEMS ARE SMALL.
The mosses that cover these rocks hold moisture where there is no soil, enabling ferns and other plants to grow. Ferns thrive during the damp coastal winter and spring, and become dormant in the summer. Dead rotting mosses and fern fronds become the soil in which other plants take root.

→ The Northern Flicker is a common woodpecker in forests, rural areas and even cities throughout the province.

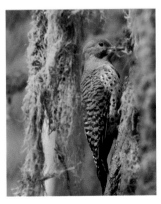

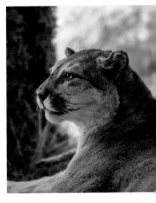

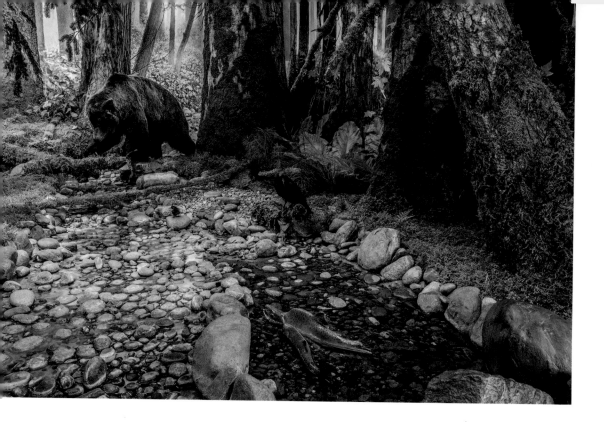

From Sea to Land

EVERY SPRING coastal rivers and streams churn with salmon swimming against the current trying to reach their place of birth, often far inland and at high elevation. The successful few will spawn before they die and produce thousands of offspring that will soon start their journey to the sea. Whether the spawning salmon die along the way or at their destination, the animals and plants of the forest rely on this annual bounty of death and decay. Another cycle is complete: BC's waterways take nutrients in their flow from the mountains to the sea, and once a year the salmon bring some of it back again.

↑ A Grizzly Bear and Common Raven scavenge for dead and dying salmon in a mountain stream.

On the Edge

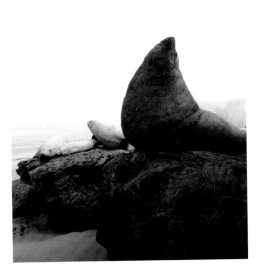

↑ Steller Sea Lions haul out on rocky coastal islands and shores to rest or mate.

THE PACIFIC OCEAN, the world's largest body of water, ebbs, flows and crashes all along the coast of British Columbia. This meeting place of sea, land and sky swarms with life, from microscopic algae to huge marine mammals.

Our coastal seashore display represents the entire coast of British Columbia, showing its flat, even beaches and its rocky, jagged edges.

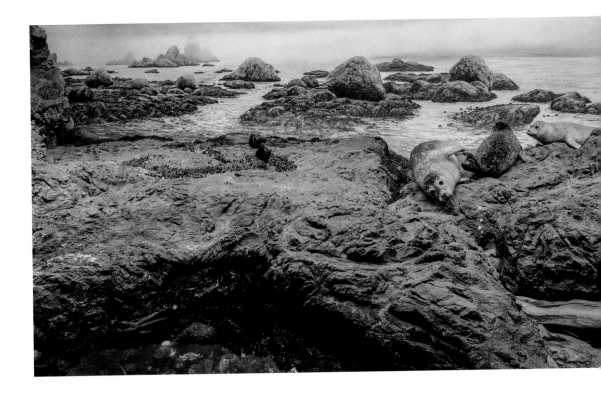

Small World, Big Changes

SEASHORE TIDAL POOLS change every day as tides rise and fall. A low tide leaves rocky tidal pools isolated for hours, and a high tide refreshes them with water and life. The residents of our tidal pool change regularly, too, brought in from and returned to the marine waters around Victoria. Look for something different every time you visit.

This tidal pool is one of just three living displays in and around the museum—the others are the aquarium in Ocean Station, a little further along in this gallery, and the Native Plant Gardens that surround the buildings outside.

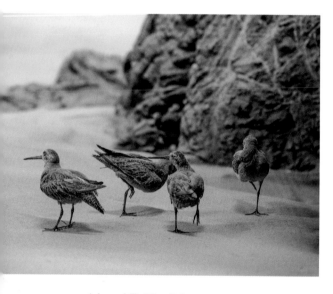

↑ Long-billed Dowitchers.

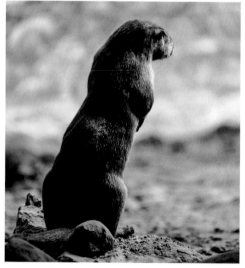

↑ Northern River Otters favour the shores of deep, clear fresh or salt water, where they hunt mainly for crabs and small fishes.

↓ Female Mallards search for plant roots and small invertebrates in the mud.

Diverse Deltas

RIVER ESTUARIES AND DELTA MARSH-LANDS are among the most productive ecosystems in the world. The largest delta in British Columbia lies at the mouth of the province's largest river, the Fraser.

Take the boardwalk to see migrating and resident birds dining on a rich variety of plants, small fishes, crustaceans and insects in the shallow waters and mud flats. Look for wintering Northern Pintails and Trumpeter Swans, and a resident Great Blue Heron standing motionless over the water, waiting to seize a fish in its long beak. And though you can't see them, sturgeon and several species of salmon migrate through the nutrient-rich waters of the estuary.

We humans bring our industries here, too, with their demand for land and water, and we sometimes introduce harmful alien species, whether by accident or on purpose. Our activities can place a great strain on vital ecosystems like the Fraser River delta.

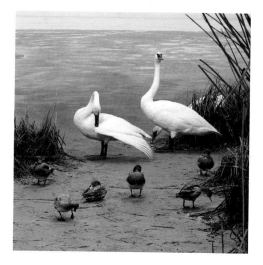

Ocean Station

MOST OF OUR NATURAL HISTORY GALLERY explores the places where *living land* meets *living sea*. But before you leave the gallery, take a short dip beneath the waves, especially if you have young children with you. The riveted hull plates may resemble Jules Verne's fictional 19th-century submarine, *Nautilus*, but our marine station is completely modern. Interactive features, such as computer games, photo albums, books, touchable specimens and an aquarium containing live animals, offer many ways to learn about life in British Columbia's marine waters.

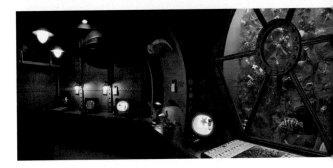

↑ The Northern (or Steller's) Sea Lion is the largest of the *eared* seals. Males may grow to four metres in length and over 1,000 kg in weight.

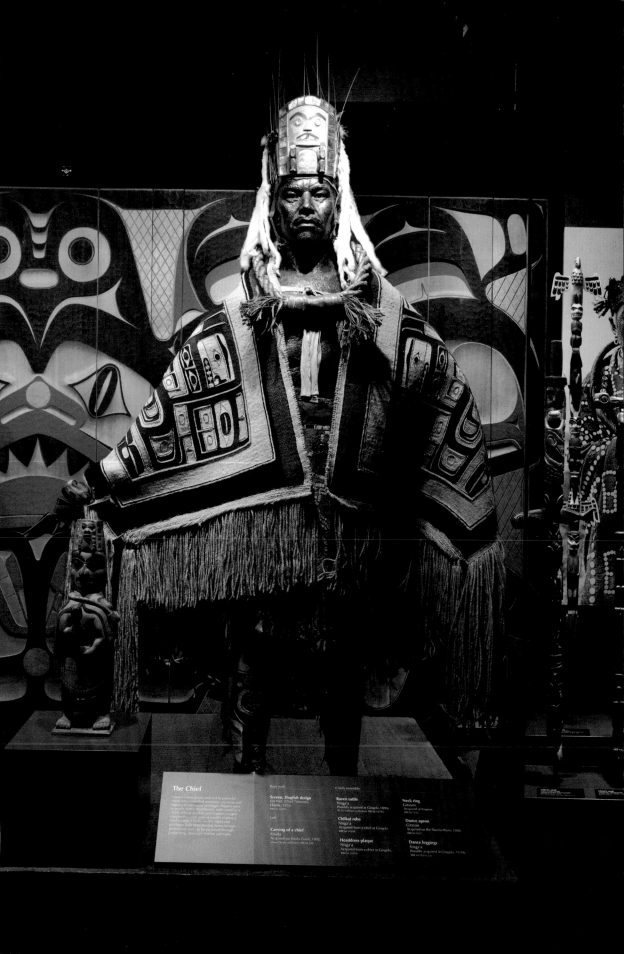

THIRD FLOOR

First Peoples Gallery

THIS RENOWNED GALLERY, installed in 1977, remains one of the most dramatic and comprehensive presentations in the world of First Nations culture, art and history. The *First Peoples* gallery sweeps through 10,000 years of history, presenting important archaeological discoveries, traditional ways of life and technologies, creative responses to European contact and colonization, resilience in the face of cultural suppression and tragic loss, and today's vibrant First Nations cultures.

← The central figure in this display of chiefly regalia shows a Nisga'a chief in his ceremonial role of *Wihalait* (Great Dancer). Nisga'a artist Norman Tait posed for this figure, which is based on a historical photograph.

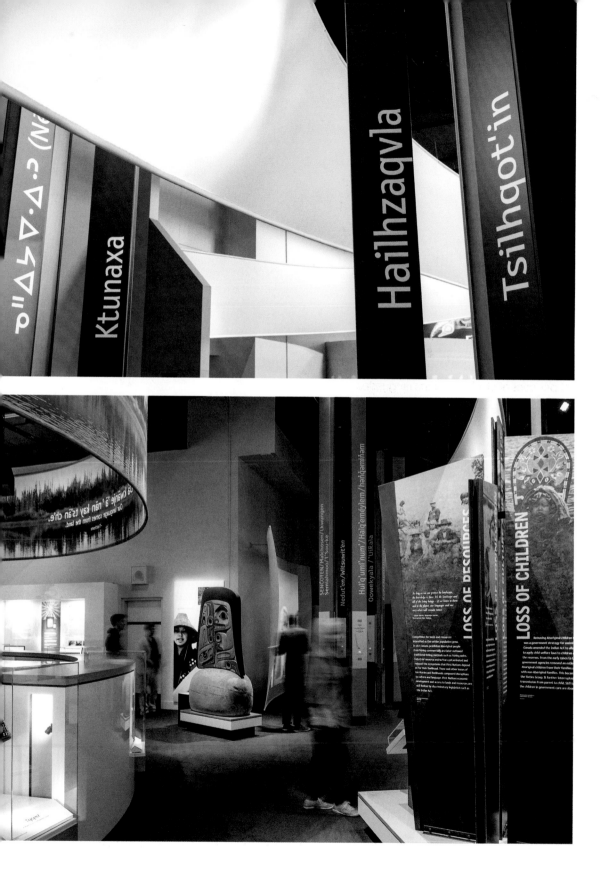

Our Living Languages:
First Peoples' Voices
in British Columbia

THE 34 INDIGENOUS LANGUAGES
in British Columbia comprise about
60 per cent of all First Nations languages
in Canada. This award-winning special
exhibition, created in partnership with
the First Peoples' Cultural Council,
celebrates the great diversity of First
Nations languages in our province and
the heroic efforts of those who strive
to preserve them.

→ While the word for
speakers' staff is different in
each First Nations language,
the meaning behind the
staff is the same. The role
of Speaker is one of honour,
which must be earned and
maintained over a lifetime.

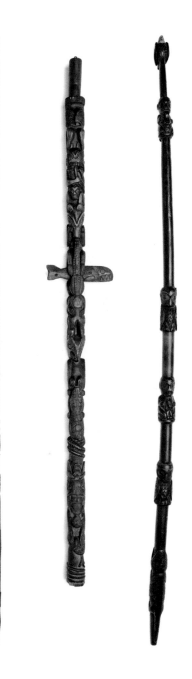

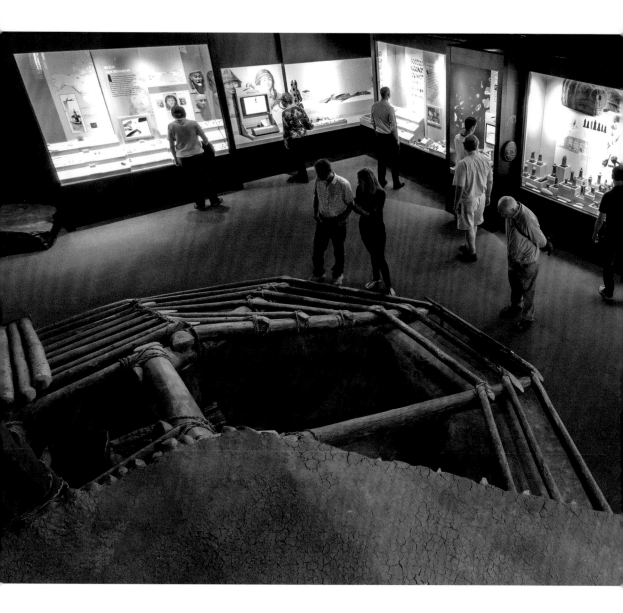

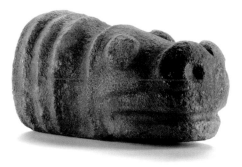

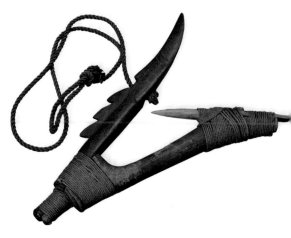

A Past That Runs Deep

PEOPLE HAVE LIVED in this region for many thousands of years. Archaeologists today rarely uncover ancient objects made of wood, skin or other perishable materials. More often they find tools, weapons and carvings made of antler, bone or stone, and these discoveries give great insights into early cultures. Some of the oldest stone artifacts date back 11,000 years.

These ancient objects, from tools to personal adornments, reveal high levels of technical sophistication and artistry, and a way of life that made full use of the rich environment.

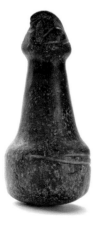

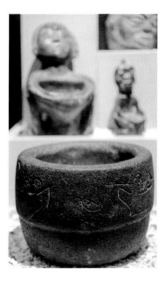

← A stone hammer in the shape of an animal's head.

← Barbed harpoon points made from antler.

← Hand maul.

→ Bowls may have held food or pigments; some were mortars for grinding and mixing.

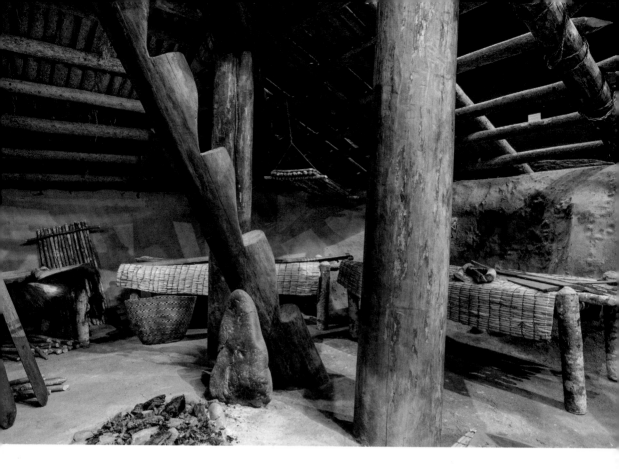

Kekuli: A Winter Home

KEKULI means "pit house" in the language of the Secwepemc people of British Columbia's southern interior. One of the oldest known forms of architecture, kekulis were once used as winter homes by people living across northern North America. Insulated by an earth-covered roof and a layer of snow, a kekuli needed only a small fire to warm its interior, which could be 20 metres across and accommodate up to 30 people.

↑ This scaled-down version of a kekuli is based on archaeological evidence and information provided by Secwepemc elder Ike Willard, who as a child lived in a kekuli.

↓ Weavers passed their basket making skills on to their daughters and granddaughters.

Traditional Fishing Techniques

SOPHISTICATED TECHNIQUES perfected over millennia enabled indigenous people to harvest and manage the abundant riches of the rivers and sea. This underwater perspective shows some of the many tools and techniques for catching a variety of fishes and other ocean creatures.

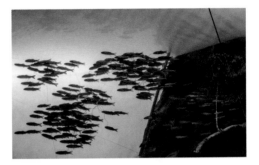

↓ Kwakwaka'wakw fisherman Tommy Hunt advised on the details of this underwater scene that shows various forms of highly specialized fish hooks and traps.

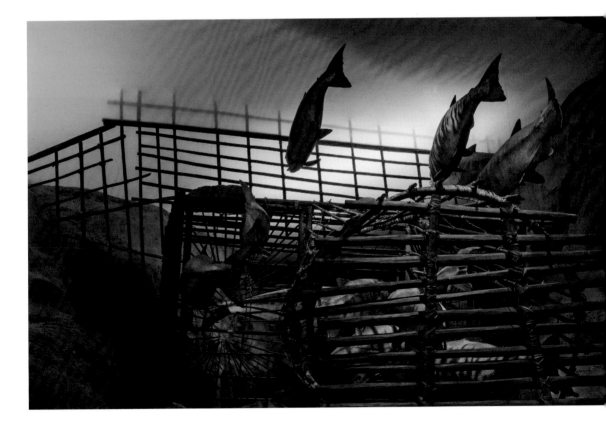

Canoe

BEFORE ROADS, the swiftest form of travel was over water. Interior and coastal peoples travelled long distances by canoe and developed strong canoe-making traditions. This Haida-style cedar dugout canoe was once used by Coast Salish people to travel in and around Victoria's Inner Harbour. The boxes, paddles and weavings in the canoe were made by modern Haida, Kwakw<u>a</u>ka'wakw and Nuu-chah-nulth artists.

↑ In the winter, snowshoes made of wood and rawhide carried travellers over the snow.

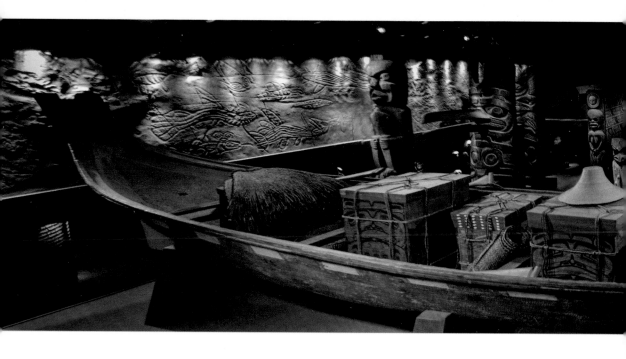

The
Supernatural
World

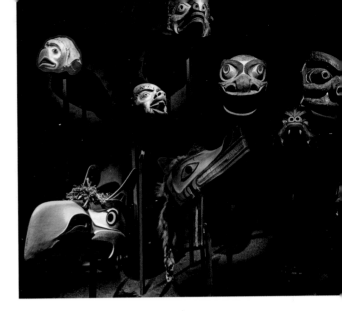

IN TRADITIONAL FIRST NATIONS THOUGHT, there is no strict division between the natural and supernatural realms. Animals can transform and become human. Supernatural creatures of the sky, earth and undersea realms interact with the human world. These masks and their stories illustrate that interaction.

Sit a while and listen as the masks light up and the voices of Kwakwaka'wakw elder Emma Hunt and Nuu-chah-nulth elders Ed Tatoosh and Monica Paul reveal the meanings of the masks.

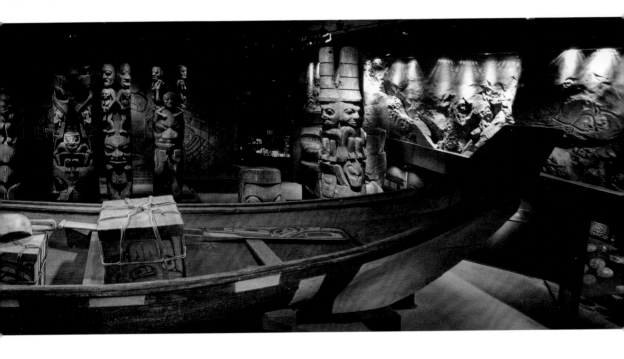

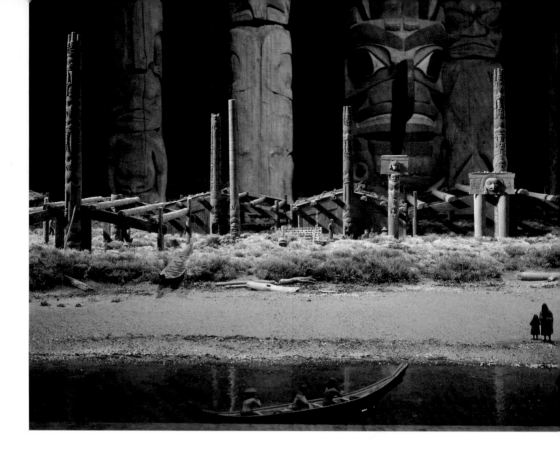

↑ The model village is based on historical photographs of q'una 'llnagaay (Skedans) on the east coast of Haida Gwaii.

A Haida Village

OUR SCALE MODEL of a 19th-century Haida village shows the great houses built with huge cedar posts that support massive beams with walls and roofs made of cedar planks. The tall, carved poles in front of the houses proclaim family histories. People spent winters in the village, but in summer could remove the house planks and use them to build temporary shelters in hunting and food-gathering areas.

Full-size poles dominate the gallery behind the village. The painted pole is a Haida housepost from Skidegate that was erected in about 1860. Beside it are sections of poles from the Gitxsan community of Gitanyow on the Skeen River.

Monumental Carvings

THE POLES IN THIS GALLERY are from many First Nations and show the different carving styles of Pacific-coast peoples. Each pole proclaims and validates a family's lineage, history, resource rights and social position. The crest figures carved on them depict supernatural beings or ancestors who met supernatural beings and acquired rights and privileges from them.

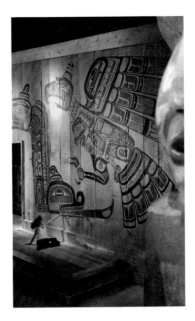

↑ The house of Chief Kwakwabalasami, the late Kwakwaka'wakw chief Jonathan Hunt, is both a museum installation and a real ceremonial house.

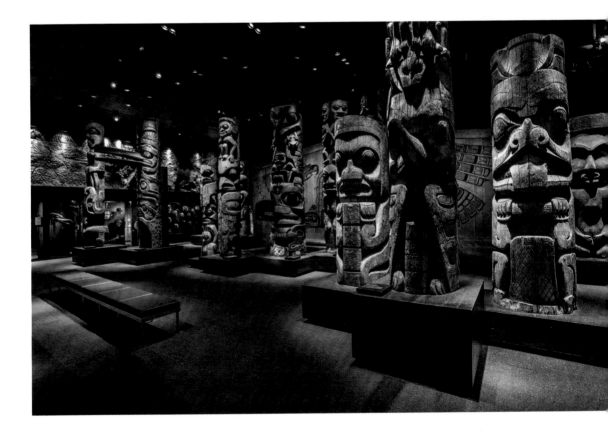

ONE TERRIBLE YEAR

AMONG the oversized portraits of First Peoples, Haida artist Bill Reid (1920–98) recites his account of the devastating smallpox epidemic in 1862 and the strength of its survivors.

———

AND SO, after perhaps 8,000 years, which saw the people slowly spread along the coastline and the river valleys, building their many languages and different ways of life, dreaming a world full of legend and myth—after all this time, in one terrible year, between the spring and autumn, it all came to an end.

Disease, firearms, liquor had already decimated some peoples and affected the rest. But the Europeans' tools and trade had at the same time brought to a fierce flowering all the ritual arts. When the horror came to the coast early in 1862, it found the villages flourishing as never before; when it died for lack of victims, the totem poles looked down on the unburied dead and the pitifully small groups of stunned survivors.

The Tsimshian lost half their people, the Kwakiutl two thirds, the Haida three quarters.

It is one of the world's greatest tributes to the strength of the human spirit that most of those who lived, and their children after them, remained sane and adapted, in part at least, to the strange new world in which they found themselves—a world that was no safe haven for a shattered people, ruled by those intent on destroying all that remained of their essential lives: their languages, their customs and beliefs. The lights in the villages burned very low for a hundred years.

Perhaps that dreadful end more than a century ago left the seed of a new beginning. Certainly the power of the old ways lived on through the long, troubled years, and the strange forms of the old arts were much too powerful to die. The people are still here, changed in appearance, in language and custom, but still alive—a part of the present with strong roots in the magic past, and their images become every day more and more a part of all our lives.

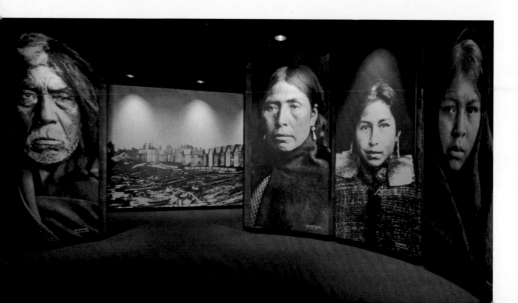

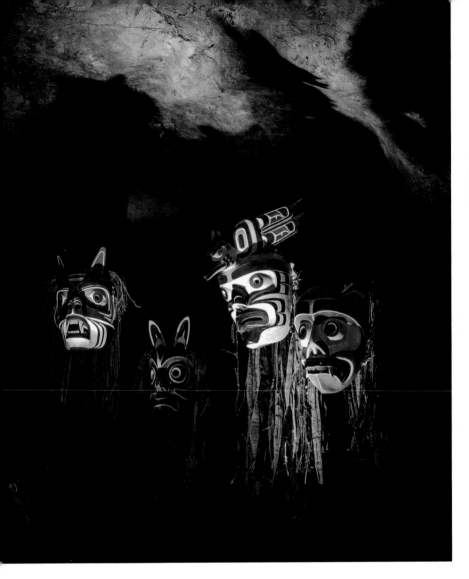

← Masks with human-like features take many forms and represent many beings.

Cave of Supernatural Power

LONG AGO when the world was young, animals held their ceremonies in a cave called *Nawalagwatsi* on what is now called Gilford Island. A man observed the animals dancing in human form. Embarrassed, the animals gave the man their dance, and it has been passed down through the generations. These are the Animal Kingdom masks of Kwakwa̱ka'wakw Chief Na̱kapánka̱m, Mungo Martin (1881–1962).

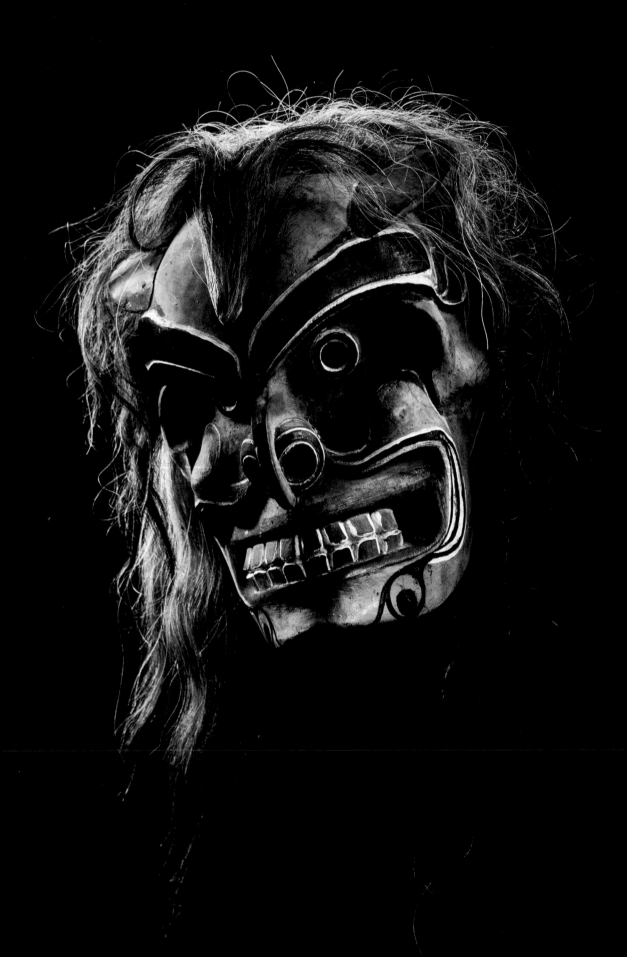

← This mask represents *Ba̲k'wa̲s*, a reclusive forest-dwelling being. A dancer wearing the mask at a Kwakwa̲ka̲'wakw potlatch would imitate the creature's secretive movements. Charles Newcombe acquired the mask at Alert Bay in 1913.

A Kwakwa̲ka̲'wakw Big House

WELCOME to the house of Chief *Kwakwabalasami*, the late Jonathan Hunt, of *Tsax̲is* (Fort Rupert) on the northeast coast of Vancouver Island. Hunt family carvers used traditional tools to create the house and its carvings.

The painted screen and two large-beaked masks refer to a time in winter and early spring when beings from the supernatural world come close to the village and the house becomes a ceremonial place. Painted on the screen is a *hamat'sa* dancer, an initiate in one of the most prestigious dances in the Kwakwa̲ka̲'wakw winter ceremony. The masks represent the supernatural birds Raven and *Huxwhukw*.

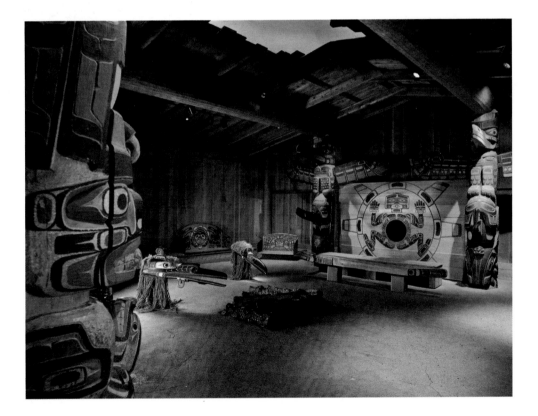

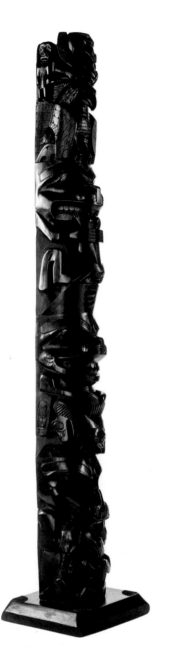

↑ An argillite model pole made in the late 1880s. At almost 88 cm tall, it is the largest in our argillite collection. The figures are (top to bottom) a mythical with a frog in its mouth and flanked by two skeletal humans, an eagle, a bear holding a frog, a dogfish holding a sea creature, and a wolf holding a frog and with a wolf cub over each arm.

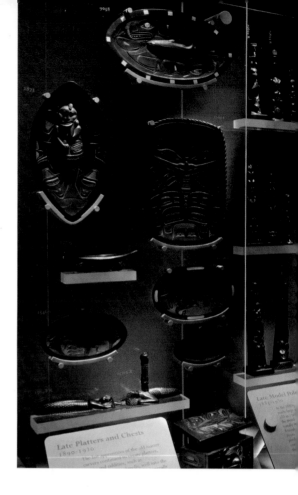

Argillite Carvings

IN THE 1820s Haida artists began carving pipes and other decorative objects from argillite, offering them to visitors for sale or trade. High-quality argillite—a shale-like rock found near Skidegate on Haida Gwaii—can be carved like wood and polishes nicely to deep black.

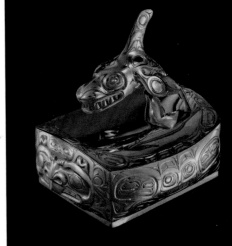

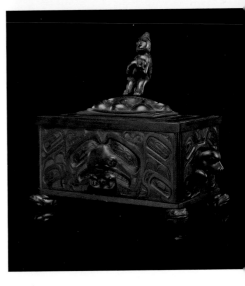

Our display traces the development of argillite carvings, from early decorated panel pipes to tableware, model poles, chests, depictions of Haida mythology and modern themes. We are grateful to the Reif family for the donation of most of these exceptional works.

↑ Haida artist Bill Reid (1920–98) was the great nephew of Charles Edenshaw and was influenced by his work. Reid made this small gold box in 1971, using jewellers' techniques to render traditional Haida designs.

↑ Large argillite chest attributed to Haida artist Charles Edenshaw (1839–1920). Featured on the lid is a tableau illustrating the Haida myth about the culture hero Raven creating human beings.

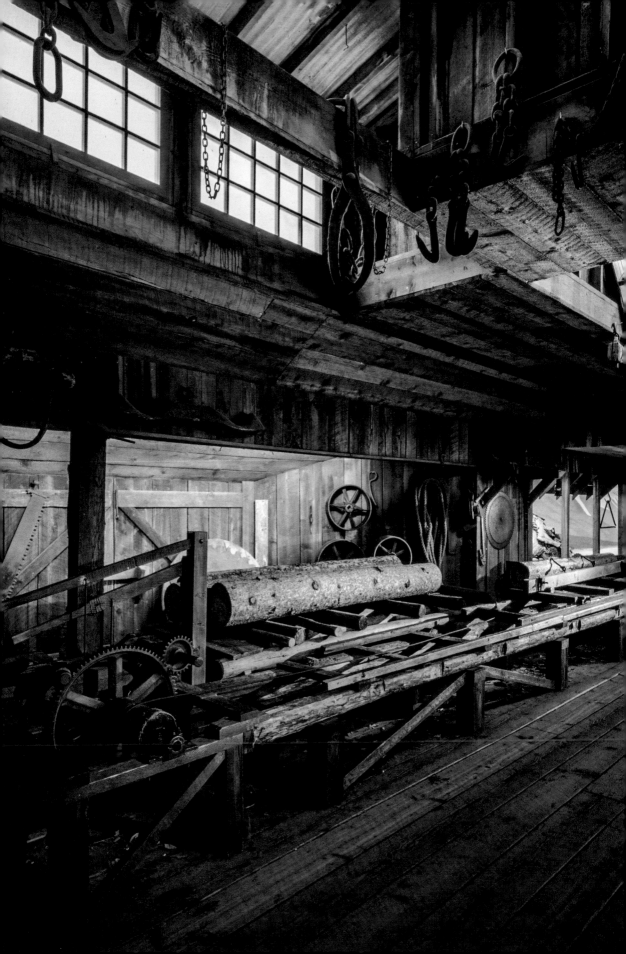

THIRD FLOOR

Becoming BC Gallery

IN THE LATE 1700s, European explorers arrived in the land Queen Victoria would name British Columbia. Early exploration brought with it waves of resource exploitation. First came the promise of wealth by sea, trading Sea Otter furs with China, and then came land-based fur traders who mapped mountain passes and routes along rivers long travelled by our First Nations. Fur trade society established partnerships with First Nations and pockets of settlements were established around trading posts, the basis of a small colonial society. Then, in 1858, the discovery of gold brought a flood of treasure seekers from around the world and up the Fraser River, creating today's routes to the interior. Many stayed and established ranches and towns, building families and new lives in resource-based economies—forestry, fishing, ranching and hard rock mining.

Metropolitan cities emerged based on resource wealth, connected by steamships to the Pacific and by railways, through the Rockies to eastern Canada. A province was born, and it flourished.

Becoming BC takes you on a dramatic journey from the roots of colonization through regional examples of our story. It explores lives lived on the land by those who made a future for themselves here in British Columbia. It also shows the impact of the industrial-resource frontier on the environmental landscape of our province, an original theme from the 1970s and a source of tension that remains part of the historical narrative of our province today. Your journey concludes in Century Hall, with a retrospective on the dynamic events and material culture of the twentieth century.

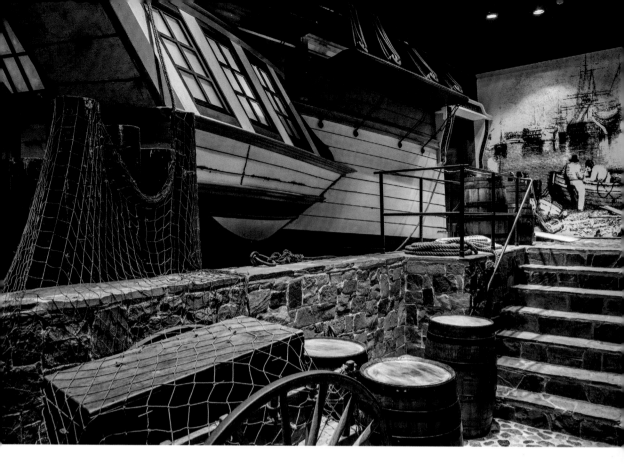

Arrivals by Sea

IN 1792 Captain George Vancouver set sail from Falmouth, England, aboard HMS *Discovery*. His orders were to chart the northwest coast of North America and to negotiate disputed territorial claims with Spain.

You can walk through our replica of *Discovery* or around its stern from Falmouth Harbour to Nootka Sound on the west coast of what would later be named Vancouver Island. There, in Friendly Cove (at the Nuu-chah-nulth community of Yuquot), Captain Vancouver met with Spanish Captain Juan Francisco de la Bodega y Quadra and began respectful discussions, later completed by others in Europe, which would result in the Spanish withdrawal from the region.

HMS *Discovery*

BUILT IN 1789, this 340-ton, three-masted, square-rigged ship carried a crew of 100 men and was armed with 10 four-pound cannons and 10 swivel guns. Our replica follows the specifications of the original ship. The captain's cabin also served as a workroom for scientific study and a social centre for the ship's officers.

↑ The flags represent four of the colonial empires that competed for this region—Britain, Spain, the USA and France. Britain won the contest with diplomacy.

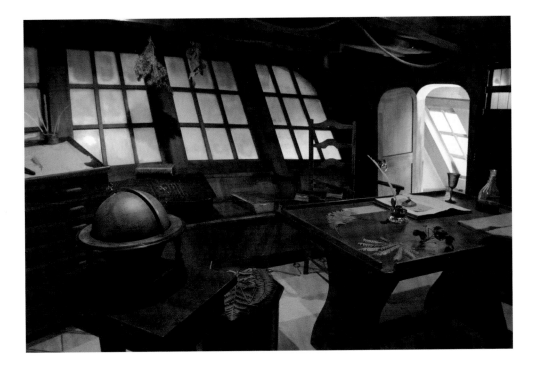

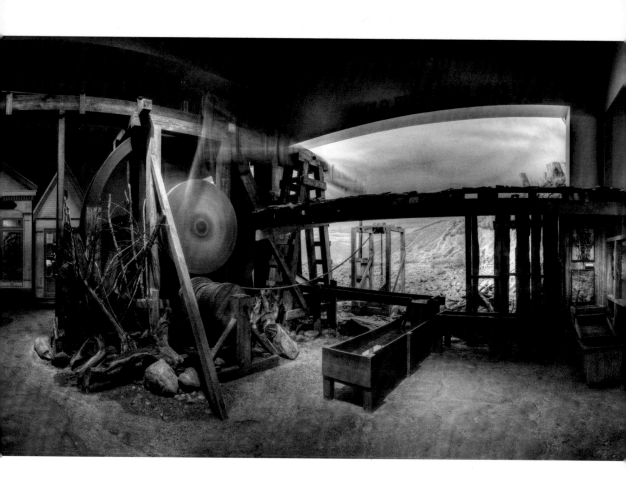

Transformed by Gold!

ONCE THE WORD GOT OUT, the small colony was transformed. The rush was on.

Starting in 1858, gold rushes swept up the Fraser River and into the Cariboo region to Barkerville. Thousands of ambitious men and women streamed through the booming port of Victoria to buy licences and supplies from newly established merchants. Colonial officials worked furiously to maintain order and respond to requests for better roads and routes. Fortunes were made outfitting miners headed to the goldfields.

Most miners left the diggings as poor as they arrived—or poorer. Only a few struck it rich and managed to hold on to their hard-earned wealth. Rich or poor, many settled in British Columbia and took up other occupations.

← In Barkerville the Cornish water wheel pumped water out of flooded mines and brought up ore.

An Endless Clatter of Cans

SINCE THE 1870s, British Columbia's canneries fed the world with exports of huge quantities of salmon and other seafood. Our cannery duplicates an early north-coast cannery at the mouth of the Skeena River, but it leaves out two details that most visitors appreciate—the harsh sounds of clattering cans and roaring machinery, and the stench of gutted fish.

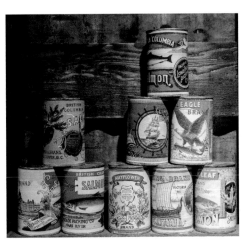

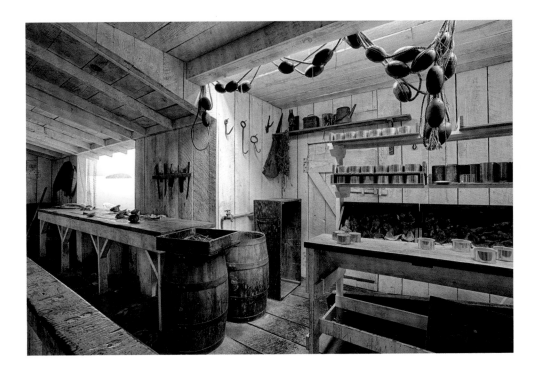

Forest to Mill

EARLY LOGGERS cut trees with basic equipment, skill and a lot of muscle power. Before the invention of the chainsaw in the late 1930s, loggers sliced through huge trees with a two-man saw nicknamed the "misery whip". Teams of oxen—and later, steam engines—hauled the logs along wooden corduroy roads to water or railroads. From there the logs were towed in booms or rafts by tugboats, or carried by steam train, to mills. Improvements in technology and transportation systems quickly made logging one of the province's largest industries.

↓ This mill is modelled after the Robinson Mill in the Rocky Mountain Trench in 1889, which produced ties for the expanding railroad in the southeastern corner of the province.

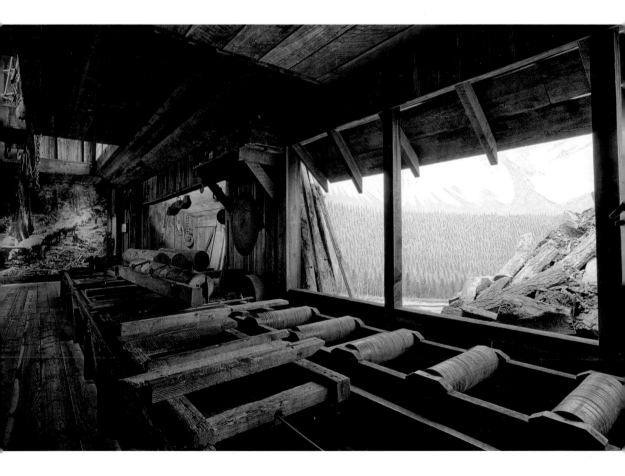

Hard, Hazardous Work

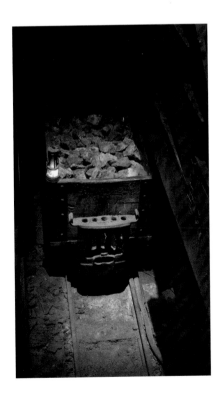

OUR REPLICA HARD-ROCK MINE,
based on the 1903 Le Roi mine in
Rossland, shows how hazardous the work
can be when extracting copper, zinc, lead,
silver or gold from the earth. Copper mining
used huge smelters to process the ore.
New jobs attracted new immigrants, such
as the Italian families who built and settled
in Trail to work in the Cominco smelter.

Vancouver Island's gas-filled coal mines
were some of the more dangerous mines
in the world, due to methane or coal gas.
Hundreds died in explosions, which led to
major union-management conflicts and new
safety measures.

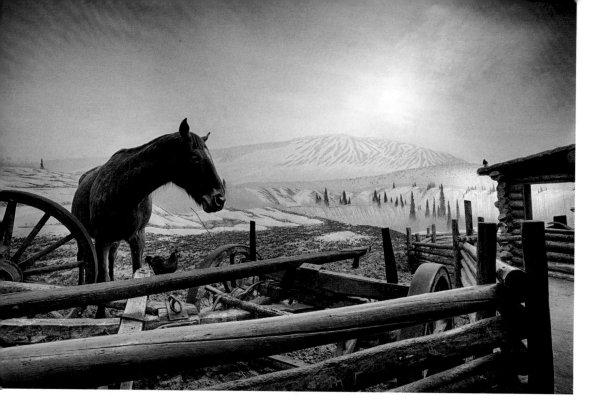

Breaking Ground

IN THE FAR northeastern Peace River district, near Dawson Creek, the Tremblay homestead sheds the snow and prepares for spring ploughing as soon as the ground thaws. This relatively flat land north of the Rocky Mountains has been a good wheat-producing region for more than a century. At the time depicted here, about 1910, animal power, not electricity or gasoline, kept farms running.

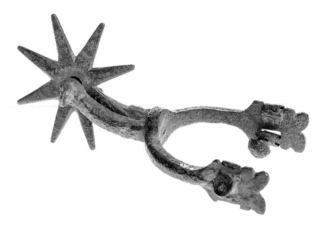

← Mexican spur with a star-shaped rowel from about 1860. The gold rush brought Spanish-American packers and cowboys north. Some of them stayed and established British Columbia's first ranches.

Arriving by Train

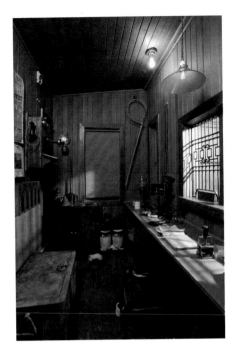

WITH THE COMPLETION of Canada's transcontinental railway in 1885, life changed for people in British Columbia. Here at the Port Moody railway station, just east of Vancouver, the train arrives on schedule with a rumbling roar, the clatter of steam rods and the shadows of passenger cars fluttering across the frosted glass windows.

The train station offers a place to rest weary feet and relax in the age of steam. It's also a pleasant diversion for children as they wait for the whistle, the screeching brakes and the magical rush of shadows—every three minutes.

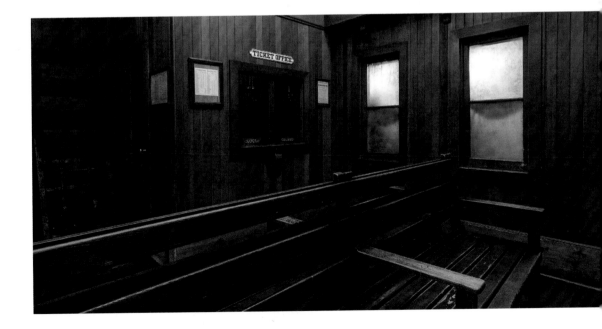

Building Towns and Cities

WELCOME to what is affectionately known as Old Town, our portrayal of the metropolitan growth that was fed by British Columbia's resource rich hinterland. Enjoy a pleasant stroll down the wood-cobbled street and engage in some window-shopping in turn-of-the-century stores. If you have the time, stop in the Majestic Theatre to watch a moving picture show.

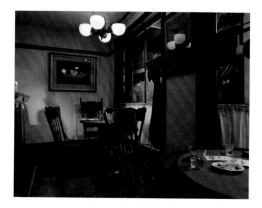

Our street divides into two decades. Oil and gas lamps glow warmly in windows of the Grand Hotel and its saloon (without the traditional blinds hiding the "sinful" bar from public view) tempts weary travellers of the 1890s. Across the street, shops of the 1910s display elegant clothing and fine china under electric lights.

The buildings in Old Town are scaled down replicas of structures that no longer exist. The Grand Hotel is modelled after Nanaimo's Royal Hotel in 1890 and the Salmon River Livery after IXL Livery in Esquimalt in 1900.

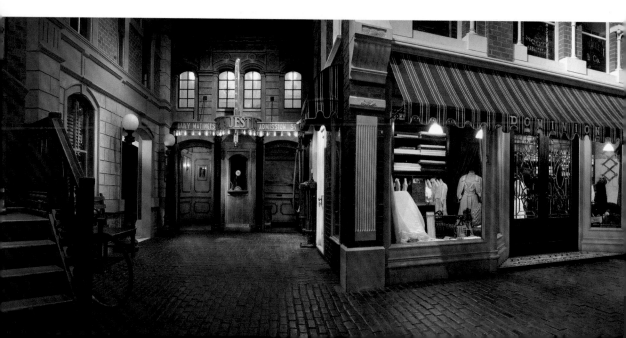

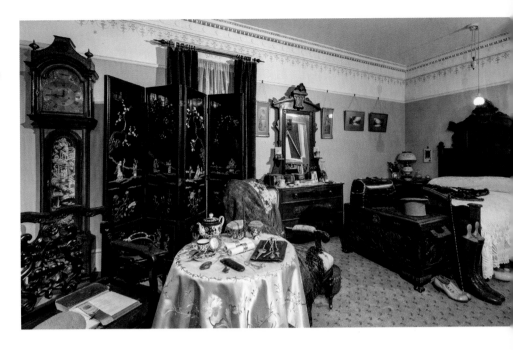

→ A room in the Grand Hotel.

Up the Stairs

LIFE at a respectable establishment like the Grand Hotel was pleasant, even luxurious, for affluent 1890s travellers. In the middle of the upstairs hallway is the well-appointed room of a couple recently arrived in Victoria after years of service for the British government in the Orient. They live in the hotel while waiting for their house to be built, and their possessions in the room reflect their travels.

At one end of the upstairs hallway, you'll find the office of an import-export business operating in about 1910. Compare this office with its counterpart in Chinatown, at the bottom of the wooden stairway at the other end of the hallway.

Before you walk down those stairs, you might catch the scent of cinnamon-spiced apple pie and hear the street sounds of the 1890s. The well-equipped kitchen may be a little larger than you would find in a typical household of the time.

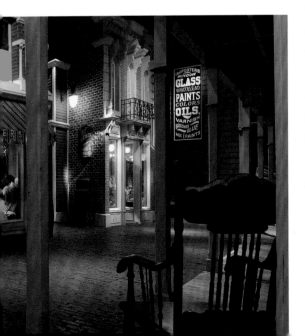

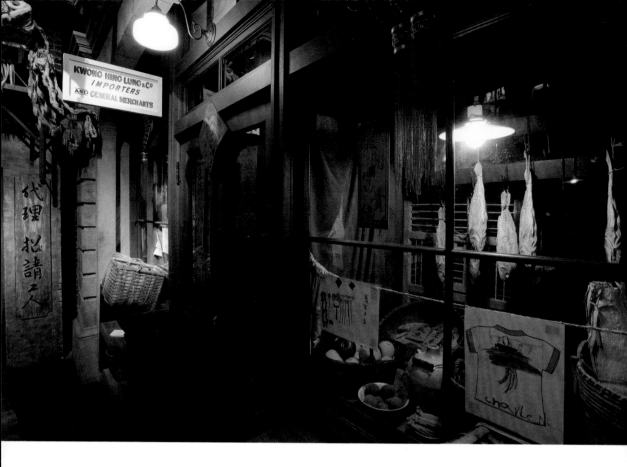

Golden Mountain Dreams

IN 1858, drawn to British Columbia by the economic opportunities associated with the gold rush, Chinese settlers in Victoria built Canada's first Chinatown. Its inhabitants lived and worked together in this protected community, surrounded by discrimination and, later, by laws that excluded them from living or doing business elsewhere.

Chinatowns in Victoria, Vancouver and many other communities have become commercial centres and tourist attractions full of cheery restaurants and bright lights. Listen carefully and you'll hear the click-clack of mah-jong game pieces and the banter of the players drifting down from an apartment above the shops.

Chinese Herbs and Tailoring Shop

Look up through the window and you'll see the unusually low floor of the second storey. Property taxes in early Victoria depended on the number of storeys in a building. In an era of stately high ceilings, early Chinese landowners and lease-holders worked out a clever system of fitting three floors into the space of two.

Shopkeepers learned how to maximize their potential by operating more than one business. This is why the proprietors of this store perform two unrelated services—tailoring clothes and selling herbs.

THIS DISPLAY is as near as you can get to the real thing. When the original shop closed in Victoria's Chinatown, we brought its contents here piece by piece and reconstructed it with all the same details.

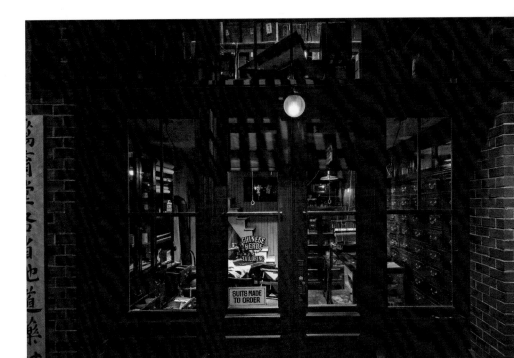

In the Twentieth Century

THE CABINETS in Century Hall hold only a small sampling of our extensive collection of clothing, entertainments and household goods that most of us, our parents and our grandparents enjoyed. They show the incredible transformations of the 20th century, which opened with gaslight and horsepower and closed with cellphones and jet travel.

↓ **This multi-band AM/FM and Mid-Band portable battery operated radio—produced between 1955 and 1959—is typical of the advanced futuristic designs brought back from Europe by Canadians serving in NATO.**

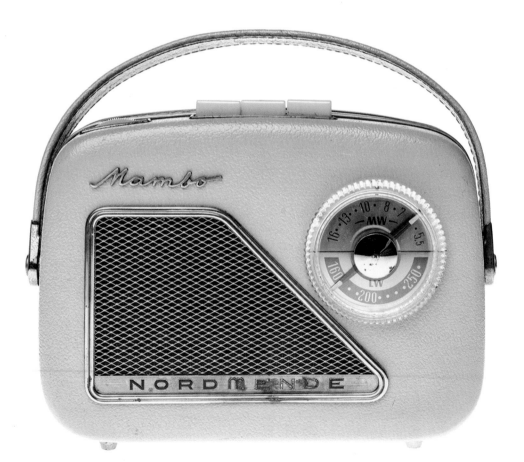

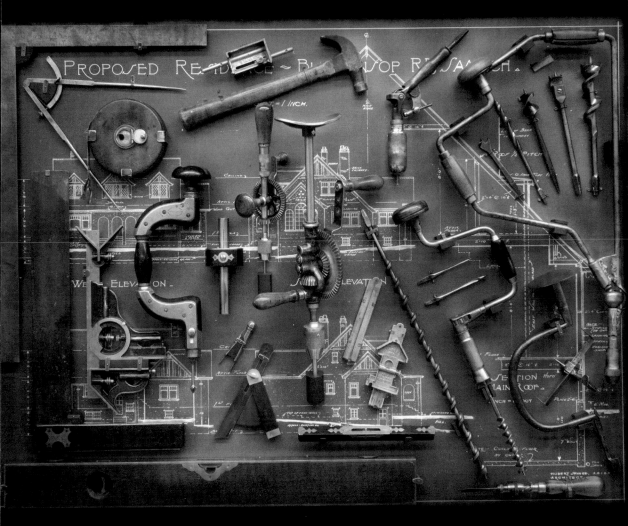

↑ Who built our cities, buildings and homes?... Surveyors, architects, draftsmen, carpenters, plasters and plumbers, to name a few. This exhibit area explores the hidden history behind the walls of our homes and Old Town's structures.

↑ Helmcken House was built in
three stages and is one of the
oldest houses in British Columbia
still standing on its original site.

Helmcken House

DR. JOHN HELMCKEN came to Victoria
in 1850 as a surgeon for the Hudson's Bay
Company, becoming a member of the
first colonial legislative assembly and
its Speaker. He helped to negotiate
British Columbia's entry into Canada as
a province in 1871. Dr. Helmcken and his
wife Cecilia—the daughter of Governor
James Douglas—raised four children in
the cabin section of their house, which
was built in 1852.

St. Ann's Schoolhouse

BUILT IN THE DECADE BEFORE 1853, St. Ann's Schoolhouse is one of Western Canada's oldest buildings. In 1858, it became a schoolhouse and convent residence for four Sisters of St. Ann from Quebec. The religious order donated the schoolhouse to the museum in 1974, when it moved to its present location overlooking Thunderbird Park.

↑ The schoolhouse was built by Jacques Lequechier in 1844 and constructed in the Hudson's Bay Company Red River style.

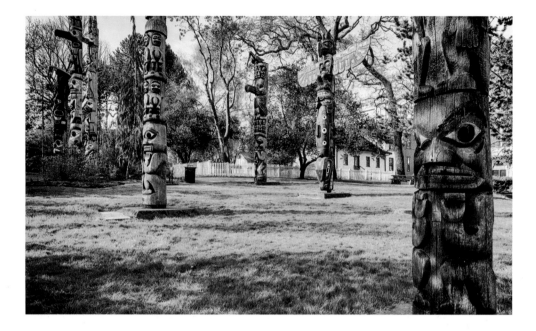

Thunderbird Park

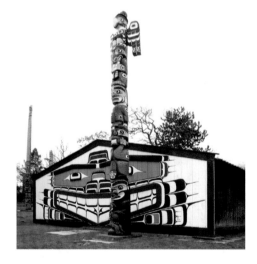

ESTABLISHED IN 1941, Thunderbird Park contains the largest open-air display of First Nations monumental art in the world. In 1952 the museum began a pole restoration program and hired Kwakwa̱ka̱'wakw master carver Mungo Martin (1881–1962) to create replica poles in Thunderbird Park. Over many years the original poles were moved to inside storage while Martin and his family carved the replicas that now stand in the park. The newest, a Kwakwa̱ka̱'wakw honouring pole raised in 1999, is the work of Sean Whonnock and Johnathan Henderson.

↑ The big house called *Wawadit'la* stands prominently in Thunderbird Park. Mungo Martin, Chief Na̱kap̲a̱nk̲am, supervised its construction and then opened it with a potlatch in 1953. Now under the cultural authority of Martin's great-grandson, *Wawadit'la* (or Mungo Martin House) continues to be used for First Nations events.

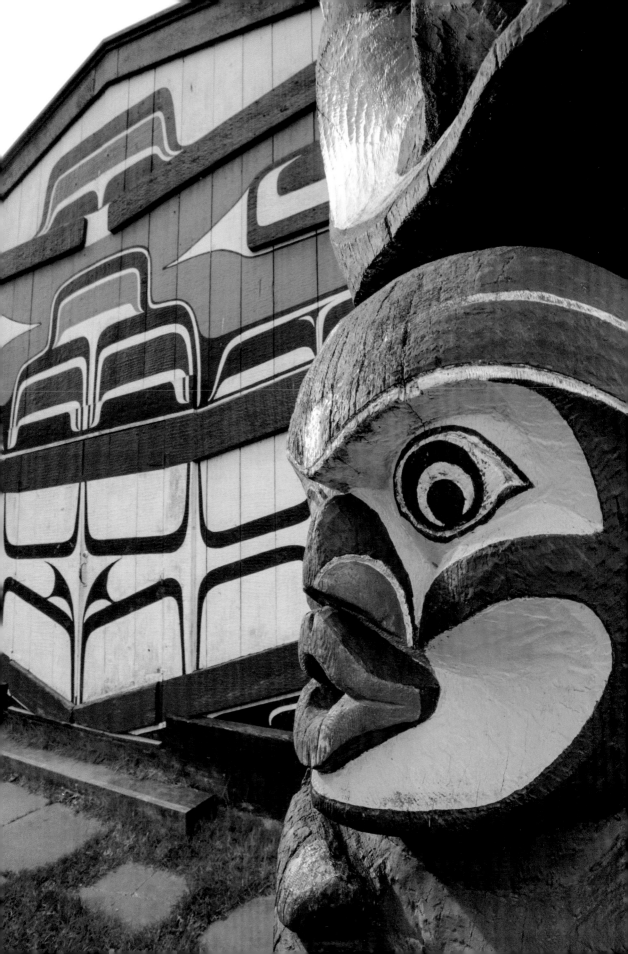

Tours

With admission, we offer gallery tours of *Natural History*, *First Peoples*, *Becoming BC*, or highlights of all three galleries. The sign in our lobby shows daily tours and times.

Access

The Royal BC Museum is accessible by wheelchair users. Please call or visit our website for information on our facilities that may help you with your visit.

Visitor Information

For general information call: **250-387-3283** or visit the Royal BC Museum website at **royalbcmuseum.bc.ca**

Be one of the first to hear about our events, exhibitions, publications and learning programs. Have all the details along with special offers sent straight to your inbox by signing up for our free e-bulletins. Visit **royalbcmuseum.bc.ca** or ask at the box office during your visit.

Hours

The Royal BC Museum is open seven days a week from 10:00 am to 5:00 pm; from June to September, we're open late most Fridays and Saturdays. We're closed on Christmas Day and New Year's Day.

British Columbia's Best Gifts

Want to make a lasting impression? Give the gift of a Royal BC Museum membership. Visit **royalbcmuseum.bc.ca/join** or visit the box office today.

Support Your Museum

A donation to the museum and archives is an investment in British Columbia. Revenue from admissions only covers a small portion of the cost of operating the Royal BC Museum. Please consider donating to help us maintain the collections, research, exhibitions, publications and learning programs. For more information please contact the Development Office at **250-387-7222** or email **donate@royalbcmuseum.bc.ca**.

The Francis Kermode Group

NAMED AFTER THE MUSEUM'S FIRST DIRECTOR, the Francis Kermode Group of visionary patrons is committed to advancing the work of the Royal BC Museum. Members enjoy a special relationship with our world-class team of curators, researchers, archivists and conservators, enhanced by social events, special privileges and customized learning opportunities.

Members receive an exclusive suite of benefits, including behind-the-scenes tours with curators, archivists and other museum professionals, an invitation to the museum's Annual Gala, opportunities to participate in selected off-site tours, free express entry to all exhibitions, admission privileges to more than 500 selected museums and art galleries across North America, complimentary copies of Royal BC Museum publications, and more.

For more information please contact the Development Office at 250-387-7222 or email donate@royalbcmuseum.bc.ca.

■ Please consider joining the Francis Kermode Group and enriching your Royal BC Museum experience. The generous financial support we receive from this group provides vital unrestricted income that helps us to meet our most pressing needs. Patrons make an annual contribution of $2,000, consisting of a $500 fee to cover membership costs and a voluntary donation of $1,500, which is eligible for an official tax receipt.

"I highly recommend that supporters consider joining the Francis Kermode Group. The activities are very enjoyable, and our financial support makes a difference to the core work of the museum and archives."

SHARON SMITH
Francis Kermode Group member
and ten-year museum volunteer

Published by the Royal BC Museum, 675 Belleville Street,
Victoria, British Columbia, V8W 9W2, Canada.

Written by Gerald Truscott and Susan Mayse, with contributions
from Dr. Martha Black and Dr. Lorne Hammond.

All images © by the Royal British Columbia Museum.
Design and layout by Lara Minja, Lime Design Inc.
Typeset in Helvetica Neue 9.5/17 and Chronicle Text 9.5/14.
Printed in Canada by Friesens.

Library and Archives Canada Cataloguing in Publication

Royal BC Museum
[Exhibit companion]

Exhibition highlights / Royal BC Museum.
Revision of: Exhibit companion / Royal BC Museum. – Rev. ed. – Victoria:
Royal BC Museum, c2008.
ISBN 978-0-7726-6733-5 (pbk.)

1. Royal BC Museum – Guidebooks. 2. British Columbia – Civilization – Exhibitions.
3. British Columbia – History – Exhibitions. 4. Natural history – British Columbia –
Exhibitions. 5. Museum exhibits – British Columbia – Victoria. I. Title. II. Title:
Exhibit companion

AM21.B74R69 2014 971.10074'71128 C2014-902243-3